DON WORTH
Photographs 1955–1985

Introduction by Hal Fischer

Untitled 40
The Friends of Photography
Carmel, California

COVER:
Echeveria 'Morning Light' and Cecropia Leaf, Mill Valley, California, 1968

Designed by Desne Border.
Photocomposition in Perpetua by Typothetae, Palo Alto.
Printed with Fultones® by Gardner/Fulmer Lithograph, Buena Park.

ISSN 0163-7916; ISBN 0-933286-44-9
Library of Congress Catalogue No. 85-81718

UNTITLED 40.
This is the fortieth in a series of publications on serious photography
by The Friends of Photography. Some previous issues are still available.
For a list of these write to Post Office Box 500, Carmel, California 93921.

THE FRIENDS OF PHOTOGRAPHY,
founded in 1967, is a not-for-profit membership organization with
headquarters in Carmel, California. The programs of The Friends
in publications, grants and awards to photographers, exhibitions,
workshops and lectures are guided by a commitment to photography
as a fine art, and to the discussion of photographic ideas through critical
inquiry. The publications of The Friends, the primary benefit received
by members of the organization, emphasize contemporary photography
yet are also concerned with the criticism and history of the medium.
They include a monthly newsletter, the periodic journal *Untitled* and
major photographic monographs. Membership is open to everyone.
To receive an informational membership brochure, write to the
Membership Coordinator, The Friends of Photography,
Post Office Box 500, Carmel, California 93921.

ACKNOWLEDGEMENTS

Don Worth is a refreshing anomaly. In a time when many push their way to the forefront of public attention, he has, in his quiet, thoughtful way, simply made the images he needed to make. This book presents a retrospective look at this prolific artist who has worked with intensity and direction during the past three decades. Worth has maintained a diversity of visual interests throughout his career, although they superficially fall within the context of what is commonly, if erroneously, referred to as the West Coast photographic aesthetic. Since he began, Worth's subject matter has ranged from landscapes and plant forms to urban views, nudes and still lifes. A master printer in black and white, he is also one of a very few artists who is equally skilled in color photography.

The photographs presented here, drawn from Worth's thirty years of image-making, demonstrate not only the variety of his interests but the continuity of his vision. His work is illuminated by Hal Fischer's thoughtful introduction, which considers Worth's oeuvre in the broader context of the history of American art, rather than of photography alone.

For his cooperation, patience and support throughout the making of this book, grateful acknowledgement is first given to Don Worth. Thanks also must go to Hal Fischer, for contributing the incisive introductory text and for working with Worth on the initial selection of images. On the staff of The Friends of Photography, acknowledgement is given to David Featherstone, for his editing of the text and his selection and sequencing of the reproductions; to Julia Nelson-Gal and Claire Braude, for their editorial assistance; and to Desne Border, for her sensitive design of the book. Finally, recognition must go to David Gardner and the staff of Gardner/Fulmer Lithograph, for so successfully meeting the technical challenge of reproducing Don Worth's tonally subtle photographs with such fidelity.

Publication of this book was aided by a generous grant from the Visual Arts Program of the National Endowment for the Arts.

James Alinder
Editor
The *Untitled* series

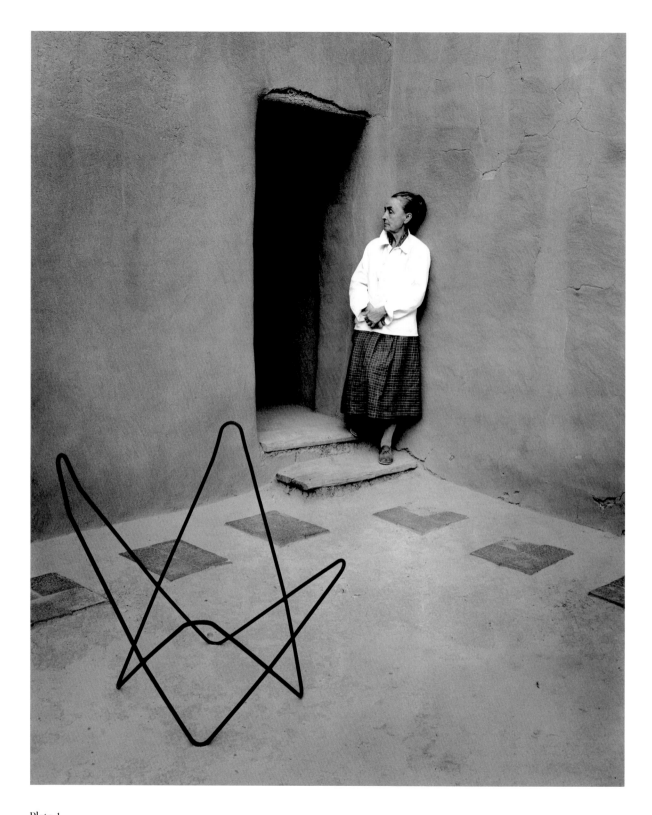

Plate 1

Georgia O'Keeffe, Abiquiu, New Mexico, 1958

THE EXACT AND THE VAST
Notes on an American Photographer

by Hal Fischer

In 1958, Don Worth gave up a seventeen-year career as a performer, teacher and composer of music to devote himself completely to photography. That same year, while on a photographic trip to the Southwest, the musician-turned-photographer made a portrait of artist Georgia O'Keeffe at her home in Abiquiu, New Mexico. The picture is an interesting anomaly to Worth's oeuvre, both in terms of its subject matter and its form. When read as a young artist's homage to a pioneer American artist, and for its very deliberate arrangement of formal elements, it suggests not only the antecedents to Worth's art, but his very particular way of seeing light and form. In a recent letter, Worth recounted the experience of making this particular photograph.

I had discovered a canvas sling chair (without its canvas) sitting in an atrium, with marvelous early evening light reflecting softly off the four surrounding adobe walls. The incisive shape of the wrought iron framework had an unearthly floating quality about it; it seemed almost suspended in space. Looking back on it now I realize that the "precisionist," hard-edged quality of that chair was imitating certain aspects of O'Keeffe's painting, although I was not consciously thinking of such a relationship. It was a purely intuitive decision when I decided that this would be an ideal spot for taking a photograph of O'Keeffe. After seeing my first print of that photograph, and after silently congratulating myself deeply upon discovering that chair, I finally realized that the chair was sitting in the patio as a very conscious little tableau for O'Keeffe's pleasure. What I had assumed was a half-discarded chair was another one of those mundane objects that has always meant so much to her. [1]

The soft light that reflects off the four adobe walls in *Georgia O'Keeffe, Abiquiu, New Mexico, 1958* (plate 1), is indicative of the clear, luminous light that informs Worth's compositions. But it is the wrought iron frame, incisive yet unearthly, that posits the dualist nature of the photographer's formal explorations–his attachment to the hard-edged shapes that imply an objective, almost scientific way of viewing the world on the one hand, combined with an equally strong desire to imbue these objects, through the agency of light, with an unearthly or metaphysical essence.

Even before he moved to California, Worth had seen

5

O'Keeffe's paintings and had been strongly moved by them. He recalls that in the Precisionist works of both O'Keeffe and Charles Sheeler he found a counterpart to the percussive and hard-edged quality that he enjoyed with the piano. Worth's conscious relating of piano to photography and his meeting with O'Keeffe while on a photographic expedition with Ansel Adams, touch on two aspects of his life that have influenced how his work has been perceived by the public over the past three decades. As a photographer who began his career in music, Worth is one of a select and well-known group that includes, among others, Ansel Adams, Wynn Bullock and Paul Caponigro. His apprenticeship to Adams and his association with the photographers who gathered at Adams' home in San Francisco during the 1950s—a community that included Brett Weston, Wynn Bullock, Imogen Cunningham, Ruth Bernhard and Minor White—has placed him, in the eyes of many critics and historians, as a second generation member of the "West Coast School."

A cursory glance at Worth's oeuvre reveals, however, an expansiveness too great to fall under a rubric of this sort. For Worth, this label has precluded consideration of his work from other perspectives, from seeing his photographs, for example, within a larger and more complex system of American values. I am suggesting that Worth, through knowledge and instinct, responds to the world in a way that transcends the limitations of the "West Coast" aesthetic as well as the self-referentiality of twentieth-century photographic history.

Worth's recollection of his portrait of Georgia O'Keeffe, a statement that neatly encapsulates how he sees, is revealing because it affords a parallel to a philosophical dichotomy of American art, the need for both the real and the ideal. The American philosopher Ralph Waldo Emerson put it another, more eloquent way when he wrote, "We want the Exact and the Vast; we want our Dreams, and Mathematics."[2] Much of American art, from the early nineteenth-century landscape paintings of Thomas Cole, in which exact details were synthesized into "ideal" views, to Mark Rothko's canvases, in which an ethereal, dream-like vision is realized through the measured and exact placement of rectangular forms, expresses a dualist sensibility, one that navigates between a desire for both the specific and the ideal.

Worth's early attraction to O'Keeffe and Sheeler is significant because both of these artists partake so thoroughly of this tradition. Sheeler's paintings, as Barbara

Novak points out in *American Painting of the Nineteenth Century*, alternated between a "form of abstract purism and a photographic realism that was, in effect, a kind of purism of the specific."[3] O'Keeffe's paintings, in addition to their precisionist qualities, suggest a sense of organic growth that would appeal to Worth's own passionate involvement with plants and flowers.

Technical precision is evident in all aspects of Worth's art. For most of his work he uses an $8'' \times 10''$ view camera to achieve maximum detail, and he is an impeccable craftsman who will often spend an entire day in the darkroom working on one negative, only to return the next day to repeat the entire process if the print has turned out either too dark or too light. Worth's pictures of plants, the body of work for which he is probably most well-known, are so precisely rendered that they function as documents of botanical specimens. This technical precision not only imbues his prints with the legitimacy of fact, but with the tonal control that can yield an abstract, luminous sense of the ideal.

Worth has never been given to philosophizing about his photographs. If prodded, he will most often respond formally, remarking on the placement of forms, or simply mentioning that he enjoyed some particular sight. He feels no need to invent elaborate rationales or theories, or to defend either his choice of subject matter or his approach. On the occasion of a large retrospective exhibition of his work at the San Francisco Museum of Modern Art in 1973, the photographer summed up his work by writing:

Once I have completed the photographic process, these vivid, tangible, compressed pieces of energy and time—time as I remember it and time as it appears in the photograph—serve another purpose that goes beyond my original desire to preserve a moment and my desire to communicate with others. They provide for me, on a strictly personal level, substantial and irrefutable evidence of my own existence. They create, for me, a super-reality which functions as an affirmation of life itself. Perhaps my primary reasons for making photographs revolve around this search for affirmation.[4]

Worth's photographs clearly have an almost mystical relationship to nature. This view is not only corroborated by many writers who have commented on his photography in the past, but is also recognized in an anecdote Worth recounted in a recent interview.

I was raised a Methodist, but I was very disconcerted with the ritual of religion as practiced in our society. The idea of going and sitting rigidly in a church pew in order to worship God didn't appeal to me because I always felt much closer to God in nature. I can recall as a teenager having these long arguments with my mother, who insisted that I go to church. I told her I didn't want to, and that I could worship just as easily walking in the woods. At one point I thought I would appease her by telling her that I was a pantheist. But of course my mother, not knowing what a pantheist was, thought it was terrible to be a pantheist rather than a Methodist. [5]

This pantheistic approach to nature is very much part of the American tradition. In nineteenth-century America, writes Barbara Novak, "nature couldn't do without God, and God apparently couldn't do without nature. By the time Emerson wrote *Nature* in 1836, 'God' and 'nature' were often the same thing, and could be used interchangeably."[6]

The origins of Emerson's Transcendentalism, as well as its effect on American culture are complex. Already a significant step away from its foundations in Kant, Hegel and Fichte, Emerson's Transcendentalist philosophy has been compromised by a popular usage that links it to any type of ideal or visionary thought. The following quote from Emerson's *Nature* encapsulates the author's intent for the purposes of this essay.

The noblest ministry of nature is to stand as the apparition of God. It is the organ through which the universal spirit speaks to the individual, and strives to lead back the individual to it. [7]

The particular distinction of the nineteenth-century American landscape artist was his ability to render both spirit and fact, to see, in effect, the exact and the vast. The luminist painters, artists such as Martin Johnson Heade, John Frederick Kensett and Fitz Hugh Lane, merged a brilliant, clear light (the symbol of God's immanence) with a sense of detail and ordered space to effect a pantheist realism, to create a landscape in which atmosphere was rendered metaphysical and all sense of ego eliminated. In a coda to her study of nineteenth-century painters, Novak describes the evolution of this dualistic mode in twentieth-century American art, seeing in the work of many painters–Sheeler, O'Keeffe, Rothko and Pollock among them–a duality that has its origins in nineteenth-century thought and practice.

Photography is a medium perfectly suited to this dualistic ambition, though it should be stated that it has only been in the twentieth century that American landscape photographers have, in fact, been concerned to a significant degree with both the real and the morally situated ideal. The American photographers sent out to document the western landscape in the nineteenth century were not intent upon expressing moral sentiments as were their painterly counterparts, but on creating documents of cultural progress; they were perceived simply as "workers with a camera," even if their work did earn a certain degree of aesthetic recognition.[8] Twentieth-century American photographers, bolstered by a growing awareness of photography as art, have pursued a dualist approach, maintaining the integrity of the real while creating the ideal through photographs intended as equivalents, metaphors and metaphysical images.

This consideration of Don Worth's photographs from a perspective that originates in painting is meant not to deny his connection to twentieth-century American photographers, but to extend appreciation of his work into a realm to which it seems well-suited. A prolific photographer who often works on several projects at one time, Worth is rather unconcerned with the notion of uniqueness. Ideas appear to be recycled, extended and reformed continually in his work, and the knowledge that something has been photographed before has never stopped him from making a photograph merely for the pleasure of it.

I often wonder what might have happened with the music of Mozart if he, at some point, had decided that he could no longer write as he did because of the fact that his "style" was too similar to that of the composer Haydn. I think that any consciously strong attempt to be unlike Haydn would have proven to be very detrimental to his music. And wouldn't it have been great if there had been ten other composers, as inspired as Mozart, writing in the same exact style? I do not believe that we would complain about having ten times the quantity of music, in the style of Mozart, to enjoy today. [9]

Unified by a belief in man's need to maintain his relationship with the natural world, Worth's photography has, in fact, grown over the past three decades to embrace new subject matter and experiences. Today his art encompasses five basic subject considerations: plant forms, landscape

views, male nudes, urban scenes and still lifes. While distinctions so blatant as these might seem a logical, yet rather elementary way to give consideration to thirty years of photography, it is important to realize that each theme functions somewhat like a symphonic movement, adding depth and dimension to Worth's evolving relationship with nature. An exploration of his work by theme–the course this essay assumes–is not so much intended to stress the content of Worth's images as it is to reveal the dimensionality of this artist's vision, and to show how his photographs resonate and expand upon a sensibility that is distinctively American in spirit and fact.

Earthly Delights

Don Worth's knowledge of plants is legendary. As a child growing up on a small farm in southern Iowa, he raised exotic plants. Today his house in Mill Valley, California, is a botanical oasis; house and yard overflow with the succulents, orchids and bromeliads that Worth raises. Large glass windows and the profusion of plants and flowers in the airy, light-filled living and dining areas create a synthesis between interior and exterior. The photographer's environment is a functioning metaphor of harmony between man and nature.

Worth sees plants as having extraordinary vitalistic properties, as being sustained by a vital principle that is self-evolving and self-determining. He describes plants as "visible explosions of energy coming out of the earth in slow motion." In the nineteenth century, it was the flower painters who, in contrast to the controlled, mathematically precise landscape painters, depicted nature with a sense of an organic flux, flow and development. Martin Johnson Heade's exotically rendered magnolias and orchids are precursors to Georgia O'Keeffe's pulsating white trumpet flower and Imogen Cunningham's exceptionally pristine magnolia. To the extent that they maintain a functional role as botanical documents, however, Worth's plants have a particular affinity to nineteenth-century flower imagery that is not shared by either O'Keeffe or Cunningham.

Plants not only signify a vitalistic energy for Worth, but they manifest a mathematical precision as well, a geometric sense of form as order. This synthesis of the organic and the absolute enables these images to function as metaphor, abstraction and document. Photographed at close range against simple backgrounds, the plants are rendered as vi-

brant, pulsating masses of form. Succulents such as the *Agave victoriae-reginae* (plate 3) subtly unfold from a central core, leaves and light moving towards the boundaries of the image. Light never appears to fall on these plants, but rather emanates from them with a luminist glow that delineates, but never disrupts the formal structure. The forms themselves appear infinite, always suggesting that they continue beyond the frame. Even the most common of houseplants, a utilitarian coleus (plate 6), becomes an exotic, vibrating mass of black and white tonalities when photographed at close range.

The viewer's eye never rests in these pictures; the forms constantly move the line of vision in, around and beyond the subject. Caught up in this formal play, it is sometimes difficult to remember that the subjects are botanical specimens whose Latin names are revealing of an entirely different order. The formalism of the pictures is so internal, so utterly dictated by the organic form of the plant that structure almost ceases to be visible; often the plants appear ready to lapse into the realm of utter abstraction. The subjectivity is so powerful that, as in nineteenth-century luminist painting, the artist's presence seems to have been transferred directly to the object.

A predominant, recurring formal motif in many of these images is the use of an overall pattern that functions like a field, eliminating any sense of focal point or deep space. The affinity to Jackson Pollock's early fifties paintings, to their continuum of energy and seductive expansiveness isn't coincidental; Worth, interestingly enough, acknowledges his interest in Pollock, an artist in whom Novak notes a "transcendent quietude" despite the activity of the paint.[10]

Photographing plants is a kind of touchstone for Worth, a passionate obsession and an affirmation of life and his own existence. No other aspect of his work so neatly co-joins his philosophical and formal inclinations–his fascination with forms that are organic yet absolute, and with subjects whose very exactness can be transformed through photography's mediating influence into compositions that give the appearance of being infinitely vast.

The Transcendent View

In his book *Beauty in Photography, Essays in Defense of Traditional Values*, Robert Adams writes that there is always a subjective

aspect in landscape art, something in the picture that tells us as much about who is behind the camera as what is in front of it. Landscape, that is landscape in the traditional sense of being a "view," occupies a central, ever-evolving position in Worth's oeuvre. The qualifying "view" is necessary because the term landscape, applied more liberally, could be used to describe almost all of his photographs. In direct contrast to the images of plants, however, the landscape views function as an arena where the viewer is not only presented with a continuum of vision, but where, at one particularly culminating point, the view and the subjective presence of the photographer become inextricably united.

The luminist sensibility that informs the plant images is also the basis of Worth's landscape vision. There is, to paraphrase Novak, a handling of light that "suggests an almost alchemical sleight of hand," a measured, almost classical ordering of planes that creates a sense of spatial vastness, and a subjectivity so powerful, that the artist's feeling is transferred directly to the object with no sense of the artist as intermediary. In Worth's views, as in the paintings of Lane, Heade or Kensett, light is realized through a brilliance and tonal modulation that emanates from the entire composition, rather than from a particular source.

To the luminists, light stood for a spiritual and ideal feeling that transformed the real world into another manifestation of God. Similarly, it is a spirit-in-matter sensibility that writers frequently comment on as being intrinsic to Worth's imagery. To maximize this sense of light, Worth often balances his photographs at the high end of the tonal scale, imbuing his prints with a translucent brilliance.

In many of the landscapes made in the 1960s, Worth introduced a blurred figure or made time exposures of rocks and water as a way to impart a more transitory sense to the composition. For a period of time he experimented making three successive exposures on color film, creating pictures in which the moving objects would take on a vibrant, almost pointillist effect. During this same period Worth produced many of his signature images, including *Trees and Fog, San Francisco, 1971* (plate 19). In this photograph the trees appear to emerge from a luminous, fog-like mist. The trees in the foreground, seen in detail, stand out from the other trees, which are enveloped by the controlled brilliance of sunlight filtering through the morning mist. It is the ever-present duality, the clear, precisely rendered trees in the foreground posited against a vast ethereal background, that grounds the image in both the real and the ideal.

Worth's landscape images have become more reductive over the past two decades. Compositions have been simplified, the mist and fog made more luminious, the land forms rendered more ethereal. Worth travels extensively, finding in locales as disparate as Guatemala, Ireland and Australia the environmental conditions from which to fashion what the photographer terms his "pale" landscapes. *Twilight, near Hobart, Tasmania, 1982* (plate 12), one of the most extraordinary of these pictures, almost defies description. No more than a sliver of land is caught between the reflection of sky and water, with a thin white horizon line adding the requisite note of detail and precision to the composition. These pale landscapes resemble nothing so much as the passive reveries of Mark Rothko. The atmospheric illusion and the precise balancing of forms are not, however, mere formal similarities. The abstract equivalent to the transcendent ideal found in Rothko's work is equally present in Worth's pictures.

Robert Adams writes that landscape pictures can offer three verities—geography, autobiography and metaphor;[11] in Worth's most potent landscapes, geography and autobiography are so thoroughly synthesized that the view appears to belong more to the photographer than the place. As metaphor, the images are the complete manifestation of nature as a diaphanous vessel of the spirit.

An Arcadian Image

The minor status of the male nude in modern art stands in dramatic contrast to the 2,000 years of history—from the Greek gods, to the Renaissance Christ, to the moral, neoclassical male—in which the male form was both the norm and the ideal. The ascendency of the female nude as the ideal form in the nineteenth century has much to do, according to Margaret Walters, author of *The Male Nude,* with modern society's tendency to see only sexual meanings in nakedness, to view the nude solely as an object of desire.[12]

The effete, nineteenth-century academic male, so different from the morally uplifting Enlightenment male, assumed a rather ambiguous presence in the twentieth century. Often the manifestation of homoerotic intent, or more insidiously, a thinly veiled misogyny, the male nude also took on the role of totalitarian icon in the 1930s and 1940s. A relaxing of

social strictures over the last fifteen years, however, has resulted in a reconsideration of the male form. Gay liberation has focused attention on the male nude, as have many female photographers and artists, who have contributed significantly to the contemporary artistic emancipation of the male form.

Don Worth has photographed male nudes since the early 1950s, although he did not publicly exhibit the pictures until 1969, encountering a certain level of indignation even then. Part of the problem, he recalls, was that he had posed for many of the images, an act which apparently struck some viewers as both egotistical and exhibitionist. Worth offers a more utilitarian explanation for why he served as the subject.

The use of myself as model had nothing to do with portraying my physical self, but has a great deal to do with the fact that few models are willing to arise and begin a photographic expedition when I do—and even less willing to walk around naked in the cold mist while treading upon pieces of broken beer bottles lying in the wet grass. [13]

In multiple exposures made in the 1960s, Worth superimposed images of leaves, rocks and plants over images of his body to suggest, literally, an integration of man and nature. In photographs such as *Walking Figures, Forest and Fog, California, 1969* (plate 20), he presents two slightly blurred male figures moving through a pristine, silent landscape. Motion serves to eliminate the individuality of the figures; seen in this vast landscape they become archetypal, universal. These transitory figures do not inhabit the landscape; they move through it. They are visitors, something of an apparition. The nineteenth-century American male—Thomas Eakins' swimmers on a hot summer afternoon, or George Caleb Bingham's traders floating down a tranquil river—inhabited a timeless serenity. Worth's figures, in contrast, are more agitated, symbols in the photographer's words of "the vulnerability of mankind in relation to the forces of the earth, the universe and the passage of time."[14]

In 1974, while on a trip to Central America under the auspices of a Guggenheim Fellowship, Worth made several images of the male in the landscape. In *Paul, Morning Mist, Mexico, 1974* (plate 21) the transitoriness and vulnerability of the earlier male figures give way to an image that is at once ethereal and solid. No longer an apparition, the figure manifests an element of fantasy and exoticism—a satyr-like appearance with tousled hair and beard that brings to mind Hawthorne's marble faun. He is a new man, however, quite distinct from the languid young men F. Holland Day photographed with unmistakable salaciousness, or from Imogen Cunningham's pictures of her naked spouse innocently communing with nature on Mount Rainier.

Paul, Morning Mist, Mexico, 1974 is not an utterly idyllic image. Slightly tense, almost confrontational, Worth's Arcadian appears to be guarding the luminous, sylvan glade that unfolds behind him. Positioned on a middle ground, he stands between the viewer and the ideal landscape. His eyes engage the viewer's, his body is slightly tense, alert. Civilized man—the photographer, the viewer—cast into the role of adversary or intruder, becomes an unseen symbol of vulnerability and death.

In *Paul, Portobelo, Panama, 1975* (plate 22) the model is seen against a cracked and weathered stucco wall. On the right side of the image, across from the figure, the configuration of paint and stucco creates a latent image of the model, an apparition that echoes the more solid rendering of the actual figure. The apparition injects a note of morality into the image, another manifestation of man's vulnerability in the face of time and nature. Worth's Arcadian males are not lost in some sort of innocent reverie. Ideal serenity is tempered by the reality of death, which adds a disquieting, somewhat ominous note to these images.

An Urban Pastoral
Throughout most of his career, Worth has shown a photographic interest in man-made structures. In Central America he made numerous images of what he terms "nostalgic" structures—primarily churches and civic buildings, many existing in a state of ruin. These decaying structures assume a curious life of their own; they are synthetic forms that time and erosion have imbued with certain vitalistic properties. Occasionally there is a kind of humor in this decay, as in the *trompe l'oeil*, multiple-layered facade pictured in *Demolished House, Durango, Mexico, 1972* (plate 25). At other times this transformation appears almost alchemical, as in the illusory gravestone which appears in *Cemetery, St. James, Wiltshire, England, 1980* (plate 23).

In recent years Worth has turned his attention to more modern scenes, to landscapes tenuously inhabited by both

industrial and natural forms. Worth creates what Leo Marx, author of *The Machine in the Garden,* terms the "middle landscape," an arena in which a reconciliation between civilization and nature is attempted. The middle landscape has its origins in nineteenth-century America, in a culture caught between an ideal grounded in nature and the rise of an industrial and predominately urban culture. The pastoral ideal, as a mediation between industrial expansion and nature, is a central paradox of nineteenth-century creative expression. Predictably enough, nineteenth-century American painters tended not to emphasize culture's encroachment on nature, while photographers, utilizing an invention of the industrial revolution, placed themselves more emphatically on the side of progress.

In twentieth-century art, a synthesis of the real and ideal is often effected by neutralizing the real through luminist-like clarity and abstract purism. Sheeler's monumentally silent factory, depicted in the painting *American Landscape,* is for Marx the industrial landscape pastoralized. He writes, "By superimposing order, peace and harmony upon our modern chaos, Sheeler represents the anomalous blend of illusion and reality in the American consciousness."[15] With its unique capacity for rendering light and detail, photography is especially suited to this "anomalous blend."

Worth's urban views show a mix of industrial and urban artifacts—smokestacks, pipes, telephone poles, parking lots and building facades, all rendered with a hygienic clarity. The flotsam and jetsam of urban life are not to be found; the quietude and order of these pictures is of a piece with Sheeler's *American Landscape.* But Worth's images, unlike those of Sheeler, reintroduce nature as a vital, persistent force awash in a sea of asphalt and architecture. In *Two Palm Trees, Salinas, California, 1980* (plate 26), trees and bushes seem to emerge directly from the concrete to exist as organic extensions of industrial forms, and in *A Rainy Afternoon, Waikiki, 1982* (plate 27), a quartet of palm trees valiantly rises from an endless expanse of asphalt. There is a great deal of formal play to these works; picture planes are often flattened out so that natural and synthetic forms merge or extend upon one another. The images become a somewhat humorous tribute to the persistence of nature, though it is obvious that civilization has gained the upper hand.

Worth initially began making urban views as a way to experiment with subject matter that was both mundane and unbeautiful. From this perspective, the urban images play an antithetical role within his oeuvre and serve to contrast the uncompromising ideality of his landscape views. At the same time, however, they contradict the usual way in which nature and culture have been synthesized. By seeing nature within the urban milieu, as compared to seeing culture as encroaching upon nature, Worth effects a slightly tongue-in-cheek, yet thoroughly contemporary version of the pastoral ideal.

The Garden

The notion of a garden, of a well-cultivated region close to home, seems a useful metaphor with which to introduce Worth's most recent body of work, the large scale, color still lifes which the photographer prefers to call assemblages. The appropriateness of the garden metaphor is grounded in two observations. First, the tableaux are conceived and photographed at home; second, the photographer develops, or "cultivates" the assemblages from his own possessions.

Worth has experimented with other forms of "assembled" imagery such as double exposures and multiple-image printing techniques throughout his career, and he has photographed in color since the late 1950s, though he did not exhibit the work at that time because of the instability of the materials and because of a bias against color imagery by museums and galleries. Nevertheless, it is difficult, on first consideration, to reconcile this body of images to his earlier work. Both the format and the compositional complexity of these tableaux appear far removed from the reductive, ordered arrangements of his black and white imagery.

The excess of objects, the profusion of deliberately rich content—luxurious fabrics, fine porcelain and brightly hued tropical flowers and plants—creates an exoticism that is an extension of his earlier work—the orchids and bromeliads he raises and photographs, the remote locales where he often travels with his camera, and even the somewhat exotic visage of Paul, the model in his nudes from Central America. If the exoticism of these earlier images is tempered by the controlled subtleties of black and white photography, in the new work it is totally exploited in a materialistic excess that Worth admits takes as its inspiration seventeenth-century Dutch still life painting. The excess has its obsessive aspects, including extravagant expenditures of time in order to locate the costly, hand-screened fabrics on

which the porcelain, crystal, orchids and tropical plants are photographed.

Historically, still-life painting can be viewed from two distinct, though not necessarily exclusive poles. There is the conceptual realism seen in seventeenth-century Dutch still-life painting (and in American luminist painting); and there is an alternative mode, a formal approach in which the depiction or integrity of the object is seen as a secondary concern. Photographed with an 8″ × 10″ view camera and presented as 30″ × 40″ Cibachrome prints, Worth's assemblages are, in effect, a synthesis of these two polarities. When printed full scale, the objects are photographically rendered close to a one-to-one ratio, with the actual object fulfilling Emerson's dictum, "every object rightly seen." But there is little question that the reality of this representation is completely offset by a formalism that maximizes spatial confusion and, on another level, subsumes individual objects into energetic masses of color and form.

The compositions engage the duality of the real—the integrity of the object—and the ideal, although the meaning of the ideal is somewhat less obvious. The tableaux do not yield contemporary autobiographical or ideological interpretations, nor do they suggest more than a passing affinity to some of the pattern and decoration painters of the past decade. The confusion of space, a quality which to one degree or another informs these compositions, provides some understanding of their ideality. The manipulation of space, particularly in an image like *Orchids and Caladiums, 1985* (plate 31), is not merely a formal device. It infuses the composition with an abstract but nonetheless vitalistic energy, an energy that is their ideal.

The past five years have been a productive and expansive time for Worth. Images such as *Twilight, near Hobart, Tasmania, 1982* have enhanced and extended his earlier themes, while the urban views and recent assemblages are revealing of a new, more extensive consideration of subject matter. *Twilight, near Hobart, Tasmania, 1982* is perhaps the most perfect embodiment of the transcendent or metaphysical landscape that is a hallmark of his art, while *Orchids and Caladiums, 1985* presents the vitalistic, explosive energy of his earlier plant images in a form that also suggests a willingness to indulge in aesthetic pleasures encompassing both the natural and material worlds.

It is clear that Don Worth is an astute observer of nature and a careful viewer of the visual arts. To categorize him as a "West Coast School" photographer is, in his mind, to limit consideration of his work to "nature, large format cameras and a very straight approach to photography." It is also to dismiss the range of his work and its individuality. Worth questions if such a thing as the "West Coast School" even exists, or if it is not merely an imagined, historical convenience. There was a community of photographers in San Francisco that gathered around Ansel Adams during the 1950s, but it was, by most accounts, a group given little to philosophizing. Worth has acknowledged Ruth Bernhard's influence on his photography, and the impact of Adams' significant "attitude and devotion to the medium."

Reviews, essays and interviews stimulated by the more than forty-five one-person exhibitions Worth has had over the last thirty years invariably make some mention of Adams. The comparision is often a facile one, however, a categorizing of any photograph of nature into a "West Coast aesthetic." There are aspects of Worth's oeuvre, especially in the earliest images, that reveal an affinity to Adams' way of seeing, and there is no question that they share a reverence for nature that imbues their photographs with a sense of the sublime. But a comparision of signature images by these two artists reveals two very distinct perceptions of nature.

Adams' *Mount Williamson, Sierra Nevada, from Manzanar, 1944* exemplifies the kind of awesome, apocalyptic ecstasy the photographer was so adept at creating. It visualizes the forces of nature through a sense of scale and exploits the range of tonal values to show nature at its most dramatic.

Twilight, near Hobart, Tasmania, 1982 offers a more Emersonian concept of the sublime, a sublimity found in silence. The forces of nature are made almost invisible—light informs, its luminous presence, often in conjunction with water, dissolves form or renders it crystalline. Worth achieves a contemplative tranquility by clustering the tonalities at the high end of the spectrum, where they yield maximum luminosity and imbue the image with a sense of harmony and quietude.

This comparison of Worth and Adams recalls the dichotomy of ninteenth-century American landscape art, of the distinction between the large scale, grandiose views of Church and Bierstadt, and the usually smaller, more contemplative views of the luminist painters. Adams' vision is

inextricably bound to a mythic notion of the American West that originated in the early ninteenth century. Worth's vision, with its antecedents in a more contemplative and ultimately transcendent view of nature, posits a different, but equally American attitude toward the natural world. The power of this vision is evident in the realization that all of Worth's images, including those made in Europe and Tasmania, become American in spirit if not in geographic fact.

An ever-present element of Worth's art reminds us of the very exactness of things—the detailed rendering of tree bark in a fog-shrouded image, for example; the precise delineation of the horizon line in an utterly ephemeral landscape; or the brilliant, variegated surface of a caladium leaf that maintains a stubborn specificity within a profusion of color and forms. But there is invariably a vastness to his photography as well, a transcendent quietude realized in a diaphanous landscape, or an expression of vitalistic energy that comes from the plant or tree seen with both affection and awe. There is, above all, a sense of reassurance to his art, a recognition that it is possible to have both the mathematics and the dream.

Hal Fischer is a writer and photographer based on the West Coast. His essay was written under the auspices of a 1984-1985 Critical Writing Fellowship provided by the National Endowment for the Arts .

NOTES

1. Quoted from letter to Beaumont Newhall, November 1984.
2. Quoted in Barbara Novak, *American Painting of the Nineteenth Century* (Praeger, New York, 1969), p. 120.
3. *Ibid.,* p. 274.
4. *Don Worth: Photographs 1956-1972* (San Francisco Museum of Modern Art, San Francisco, 1973).
5. Quoted from interview with Paul Raedeke, *Photo Metro* (San Francisco, September 1984).
6. Barbara Novak, *Nature and Culture* (Oxford University Press, New York, 1980), p. 3.
7. Quoted in *Nature and Culture,* p. 7.
8. Shelley Rice, "Fields of Vision," *Land Marks* (Bard College, Annandale-on-Hudson, 1984), pp. 67-78.
9. Quoted from letter to Beaumont Newhall, November 1984.
10. *American Painting of the Nineteenth Century,* p. 282.
11. Robert Adams, *Beauty in Photography, Essays in Defense of Traditional Values* (Aperture, Millerton, 1981), p. 14.
12. Margaret Walters, *The Male Nude* (Penguin Books, New York, 1979), pp. 12-13.
13. Quoted from letter to Van Deren Coke, August 1983.
14. *Ibid.*
15. Leo Marx, *The Machine in the Garden* (Oxford University Press, New York, 1964), p. 356.

CHRONOLOGY

1924 Born in Hayes County, Nebraska. Family moves to Iowa two years later. Grew up on farm forty miles south of Des Moines.

1932 Began study of piano.

1934 Became intensely interested in the cultivation of exotic plants.

1941 Graduated from high school.

1945 First serious photograph—of an exotic plant.

1949 Bachelor of Music degree from Manhattan School of Music. First public performances of musical compositions. Began a more serious interest in photography.

1951 Master of Music degree from Manhattan School of Music. Post-graduate study in musical composition with Virgil Thomson.

1955 Post-graduate study at Mills College, Oakland, California, in composition with Darius Milhaud and piano with Alexander Libermann. Continued public performances of musical compositions. Began photographing with 8″ × 10″ view camera. Met Ansel Adams. Began public exhibition of photographs.

1956 Moved to San Francisco and began working as assistant to Ansel Adams; continued in this capacity until 1960.

1957 First one-man exhibition—at the George Eastman House, Rochester, New York, to be followed by some fifty solo shows during next twenty-eight years.

1958 Composed musical score for the film *Ansel Adams, Photographer*. Termination of an intensive seventeen-year involvement with music as a performer, teacher and composer.

1962 Appointed as instructor of art at San Francisco State University. Promoted to assistant professor in 1967, to associate professor in 1971 and to full professor in 1977.

1969 First photographic trip to Mexico.

1972 Continued to travel and photograph in Mexico.

1973 Sixteen-year, 150-print retrospective exhibition at San Francisco Museum of Modern Art.

1974 Awarded Fellowship from the John Simon Guggenheim Memorial Foundation in order to travel and photograph in Canada, Mexico, Central America and the United States.

1977 One-man exhibition at The Friends of Photography, with catalogue *Plants, Photographs by Don Worth (Untitled 13)*.

1979 Traveled and photographed in Mexico and Central America.

1980 Received Photographer's Fellowship from the National Endowment for the Arts. Photographed in Europe and the Caribbean, and in the following two years in Australia and Tasmania. Renewed interest in music.

1983 Decreased teaching involvement at San Francisco State University to part-time.

1984 Renewed interest in color photography. Intense exploration of still life.

1985 First used Polaroid 20″ × 24″ camera as a part of *The Carmel Project* at The Friends of Photography.

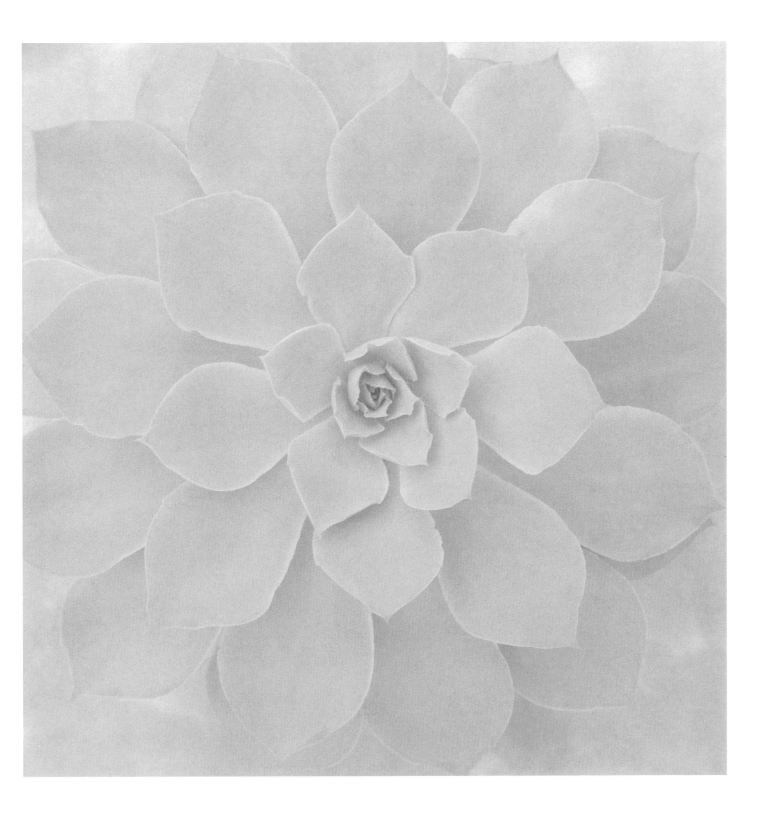

Plate 2

Succulent: Echeveria 'Morning Light,' Mill Valley, California, 1972

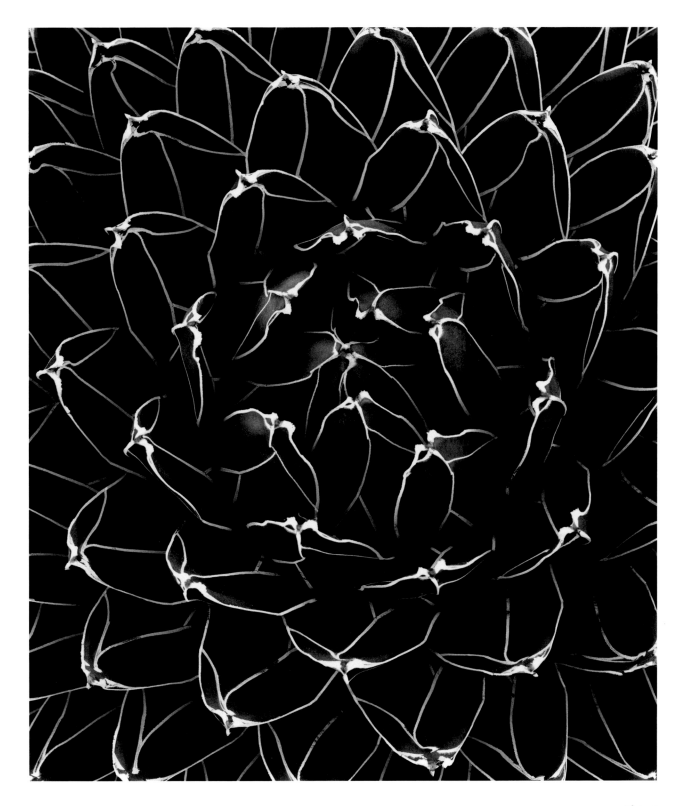

Plate 3

Succulent: Agave victoriae-reginae, Cuernavaca, Mexico, 1975

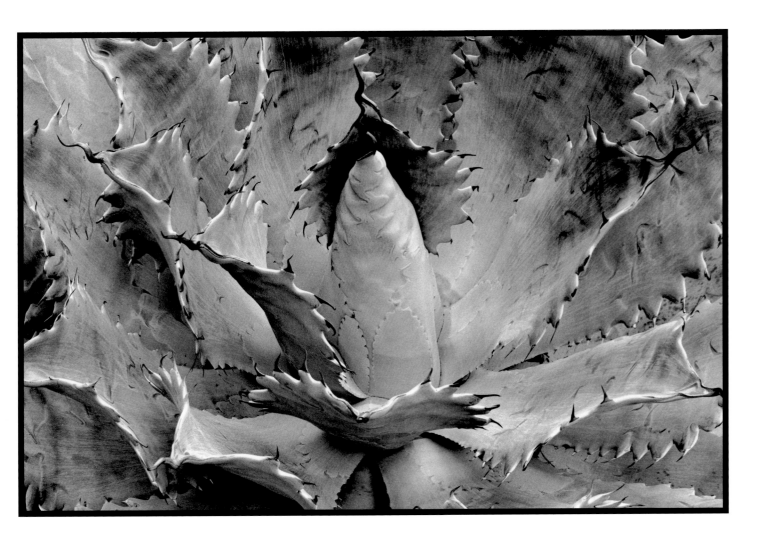

Plate 4

Succulent: Agave potatorum, Mill Valley, California, 1973

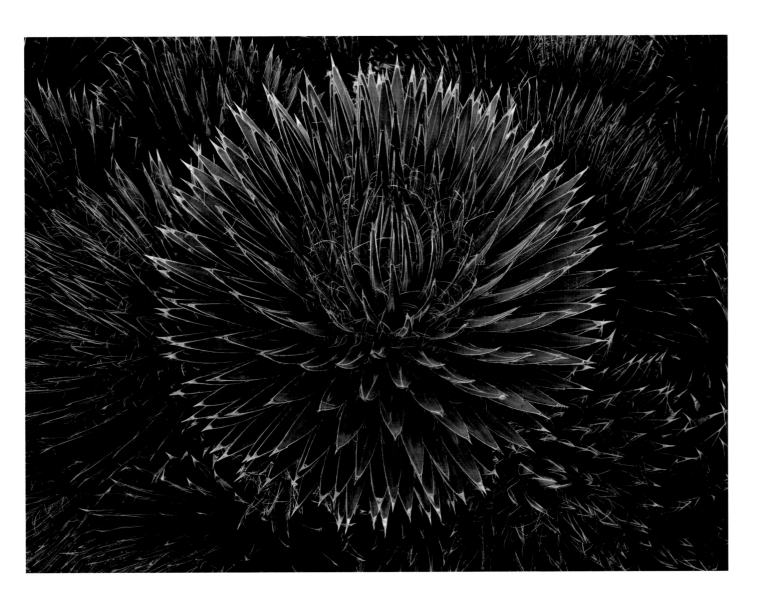

Plate 5

Succulent: Agave filifera, San Marino, California, 1979

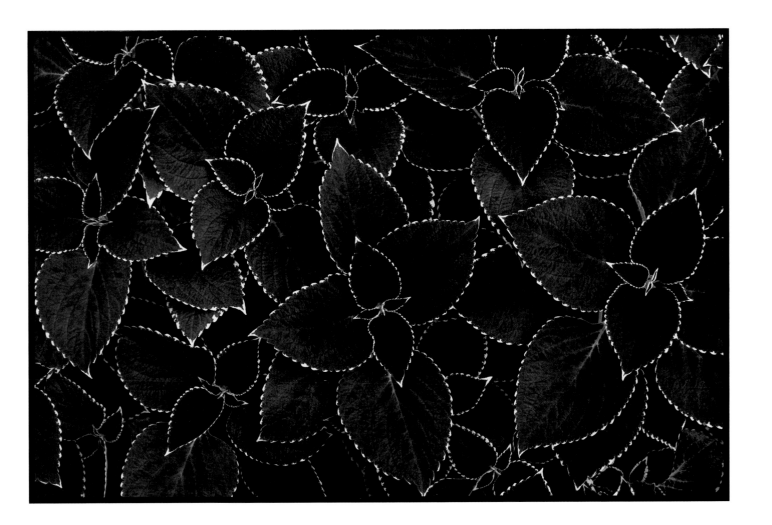

Plate 6

Coleus, San Francisco, 1977

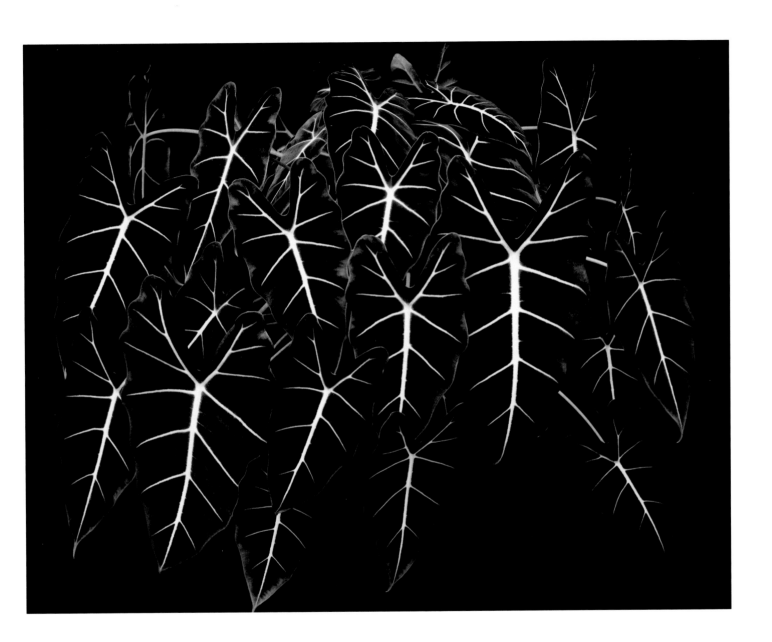

Plate 7

Alocasia 'Green Velvet,' Mill Valley, California, 1983

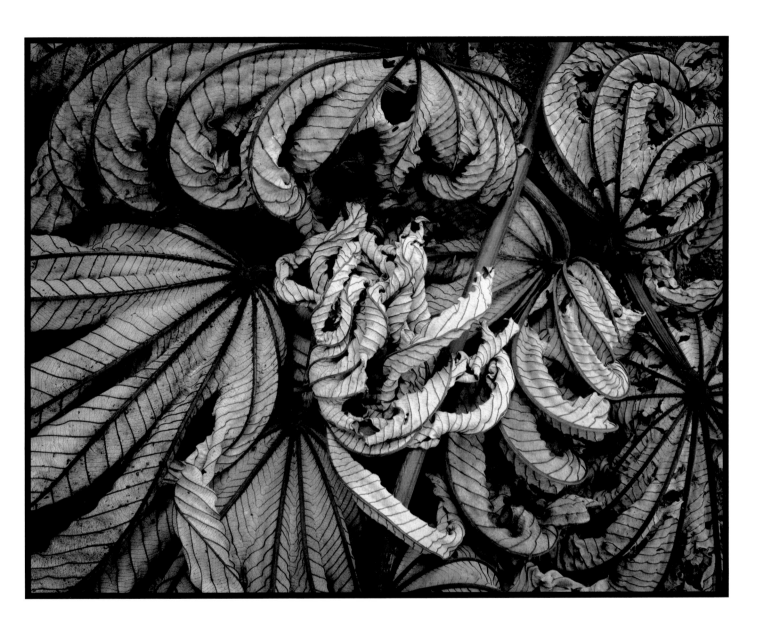

Plate 8

Cecropia Leaves, near Hilo, Hawaii, 1983

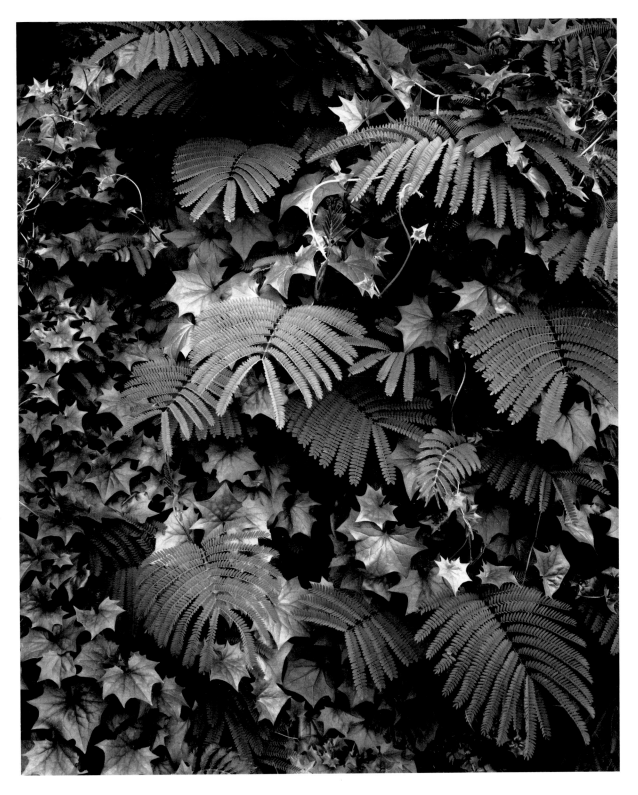

Plate 9

Wild Vegetation, San Francisco, 1978

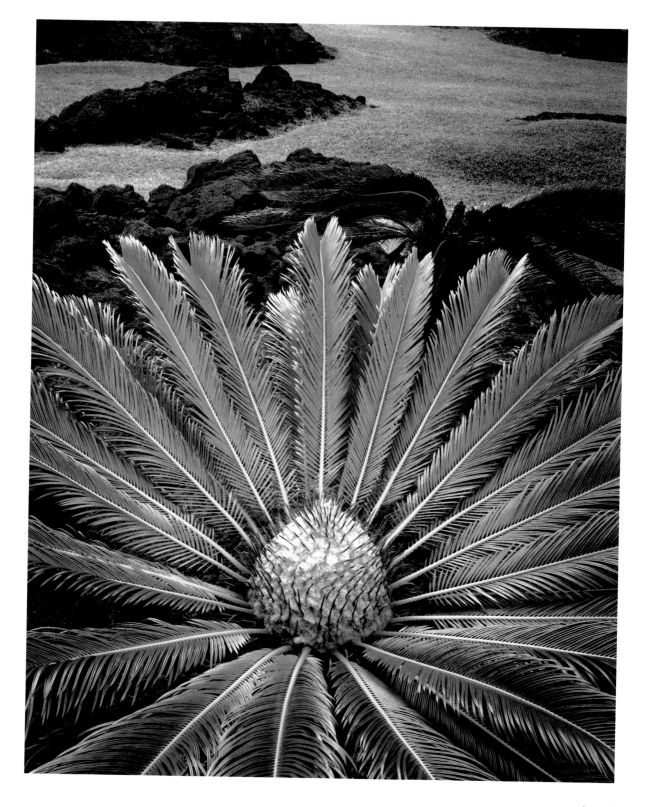

Plate 10

Cycas revoluta, Hilo, Hawaii, 1977

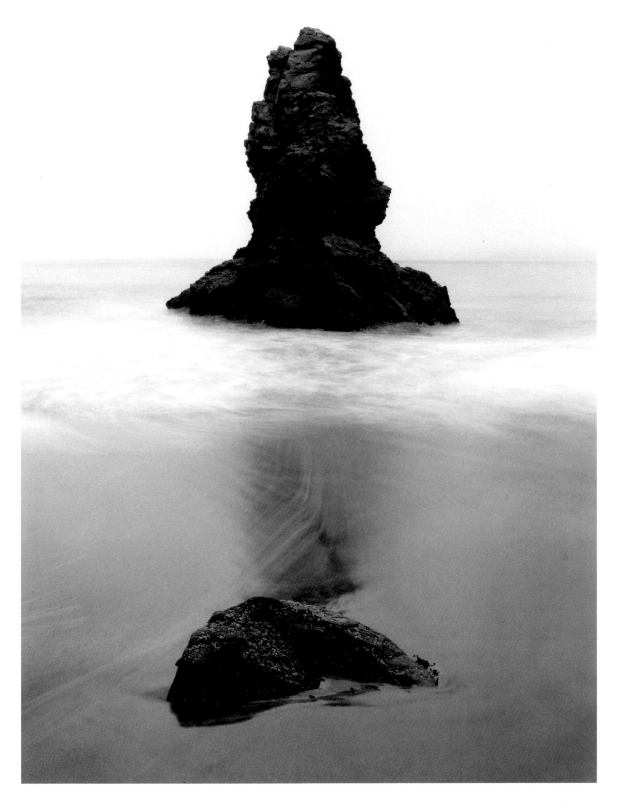

Plate 11

Rocks and Surf, San Francisco, 1969

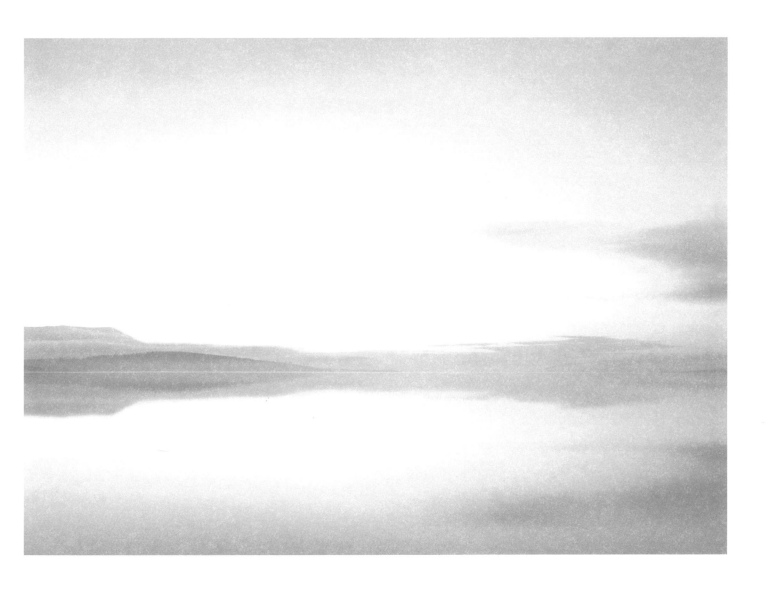

Plate 12

Twilight, near Hobart, Tasmania, 1982

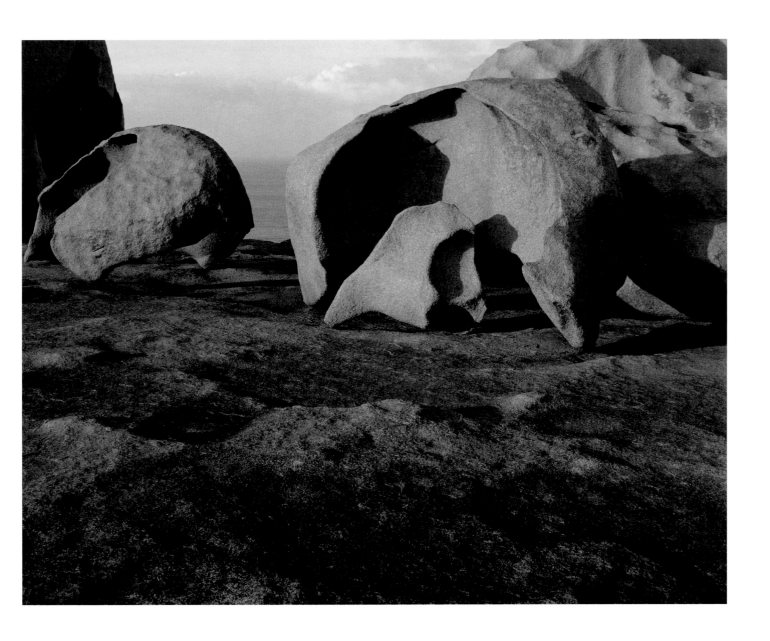

Plate 13

Remarkable Rocks, Kangaroo Island, Australia, 1981

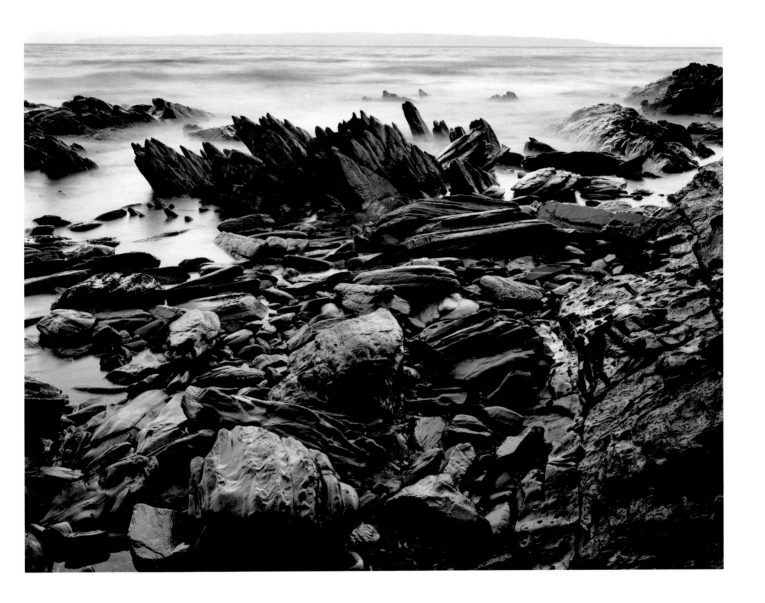

Plate 14

Rocks and Surf, Kangaroo Island, Australia, 1981

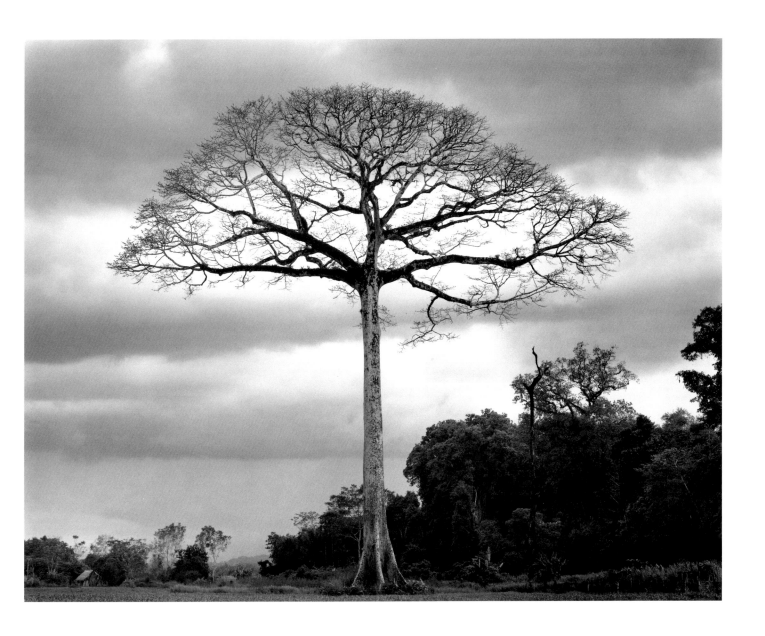

Plate 15

Tree and Rain, near Palmar Norte, Costa Rica, 1975

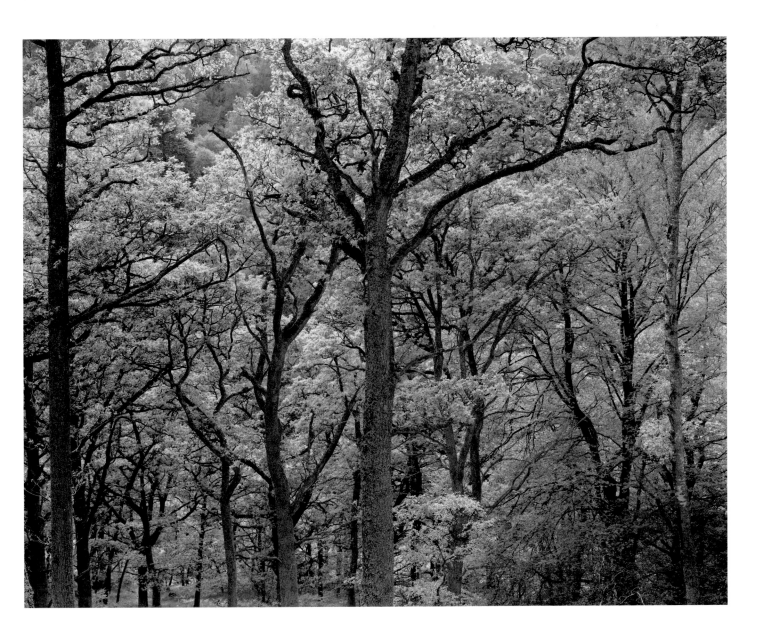

Plate 16

Forest in Spring, Scotland, 1980

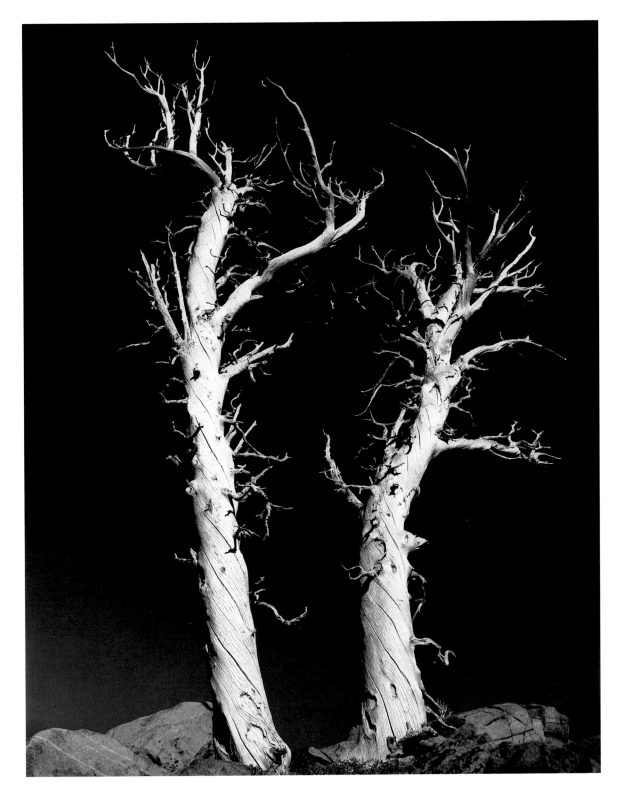

Plate 17

Dead Trees, Sierra Nevada, California, 1955

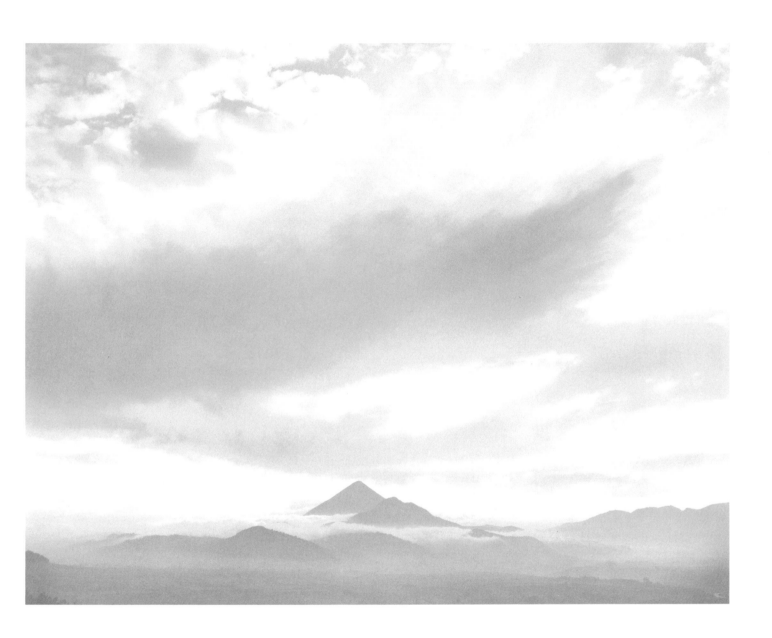

Plate 18

Mountains and Mist, Guatemala, 1975

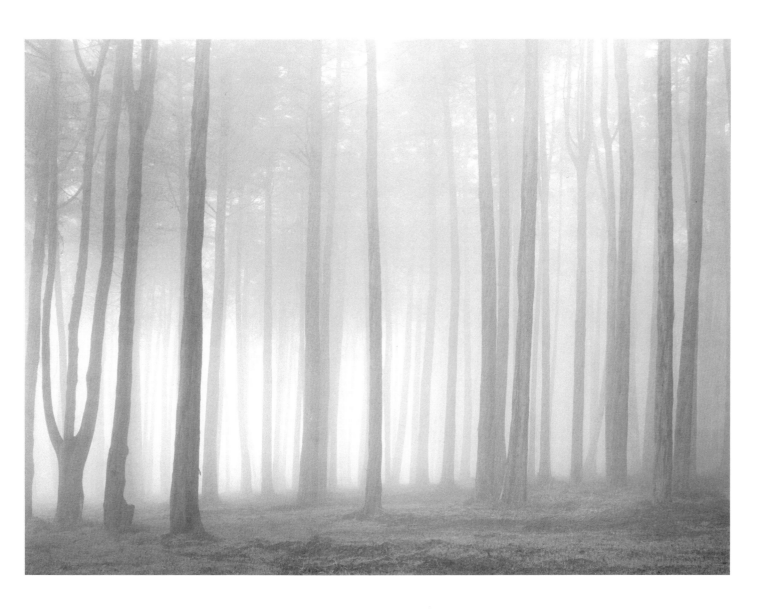

Plate 19

Trees and Fog, San Francisco, 1971

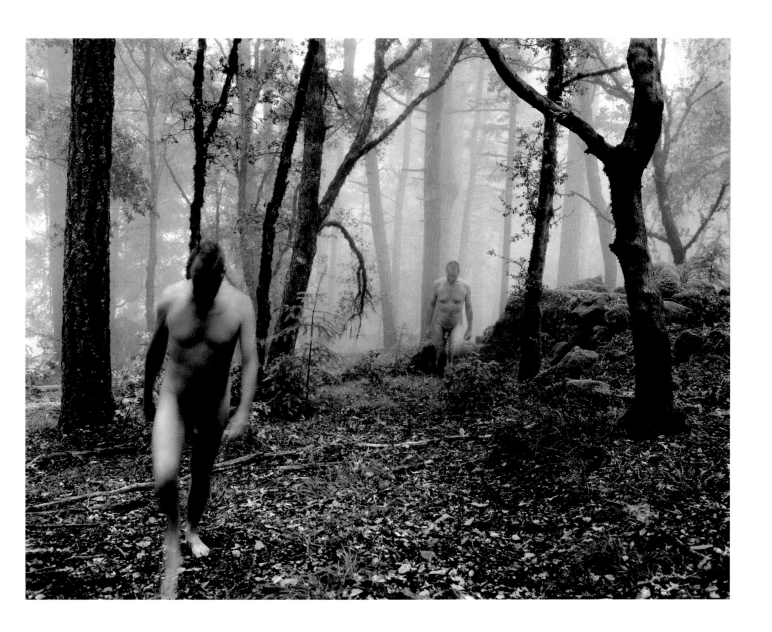

Plate 20

Two Figures, Mt. Tamalpais, California, 1969

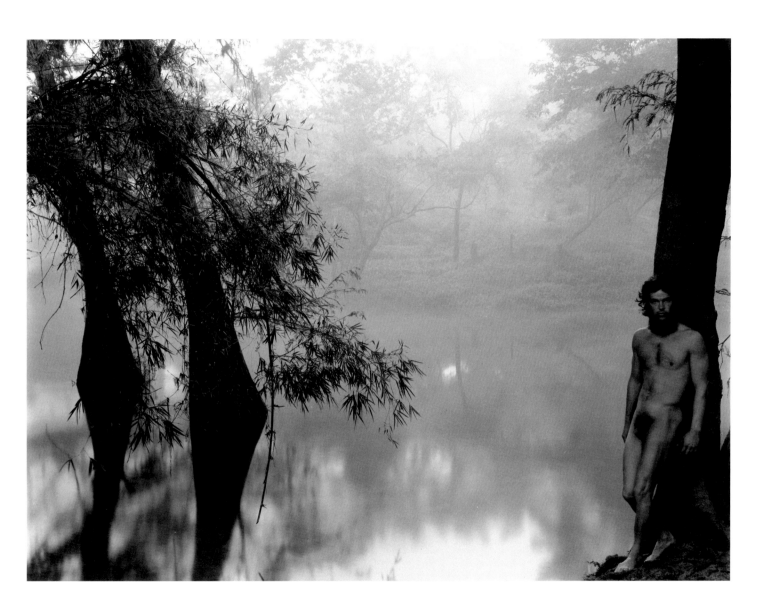

Plate 21

Paul, Morning Mist, Mexico, 1974

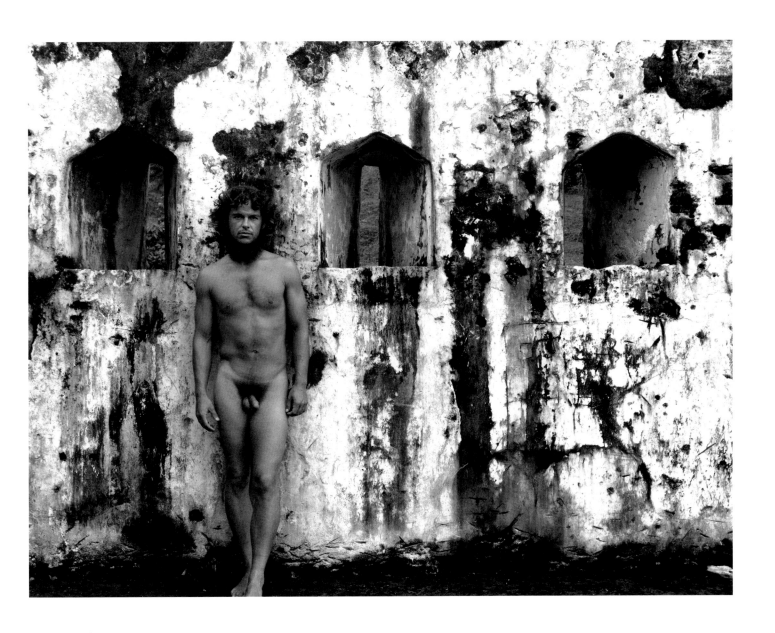

Plate 22

Paul, Portobelo, Panama, 1975

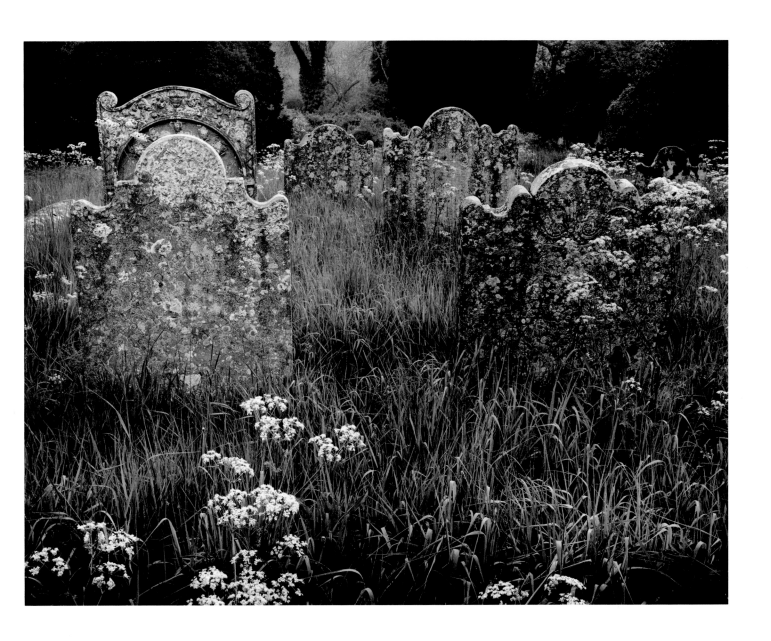

Plate 23

Cemetery, St. James, Wiltshire, England, 1980

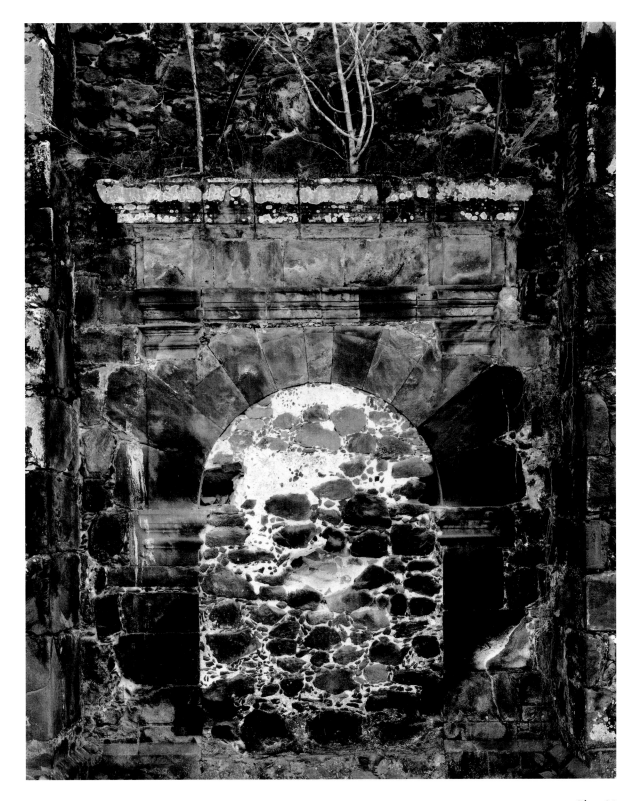

Plate 24

Cathedral Ruins, San Blas, Nayarit, Mexico, 1972

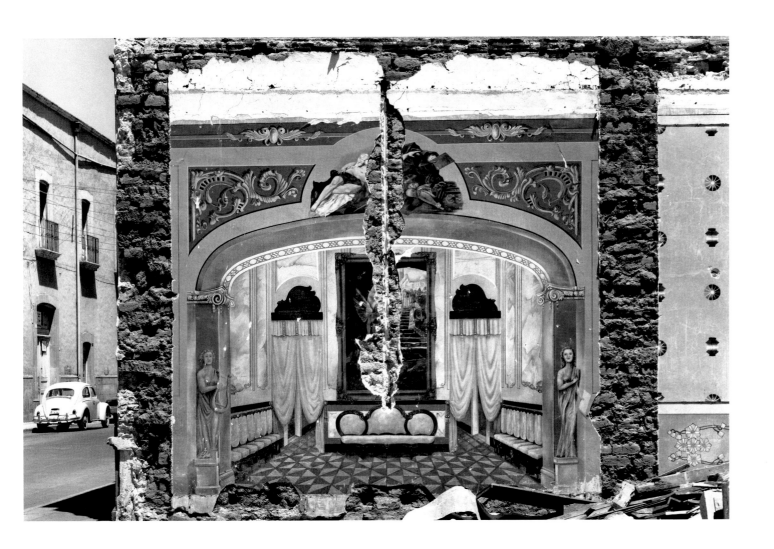

Plate 25

Demolished House, Durango, Mexico, 1972

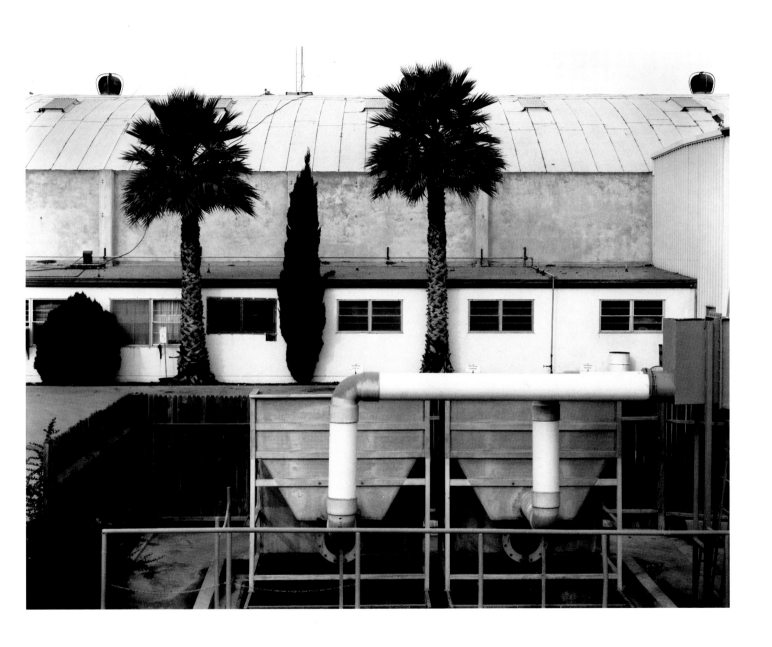

Plate 26

Two Palm Trees, Salinas, California, 1980

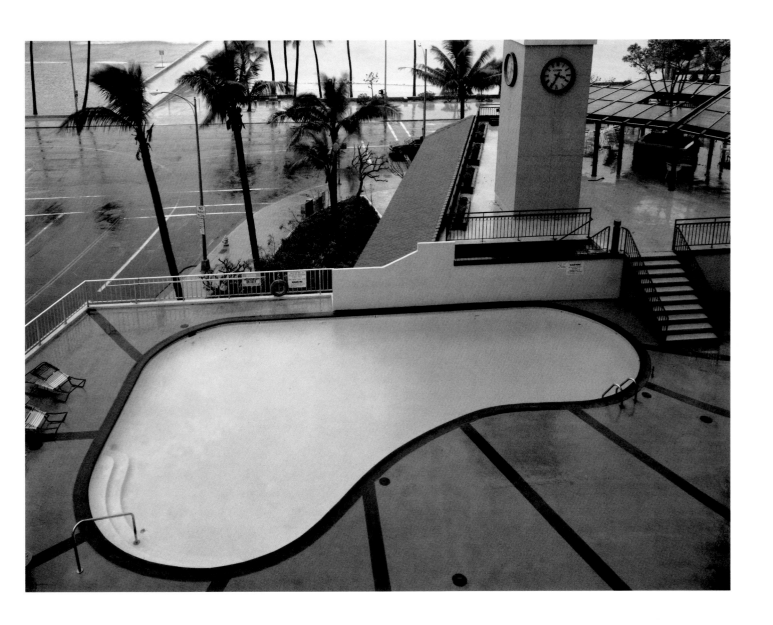

Plate 27

A Rainy Afternoon, Waikiki, 1982

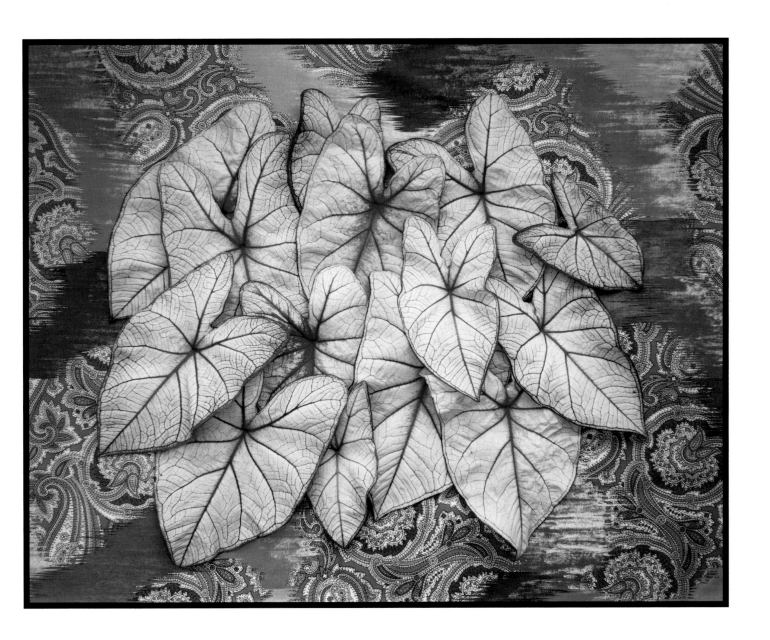

Plate 28

Caladium Leaves, Mill Valley, California, 1984

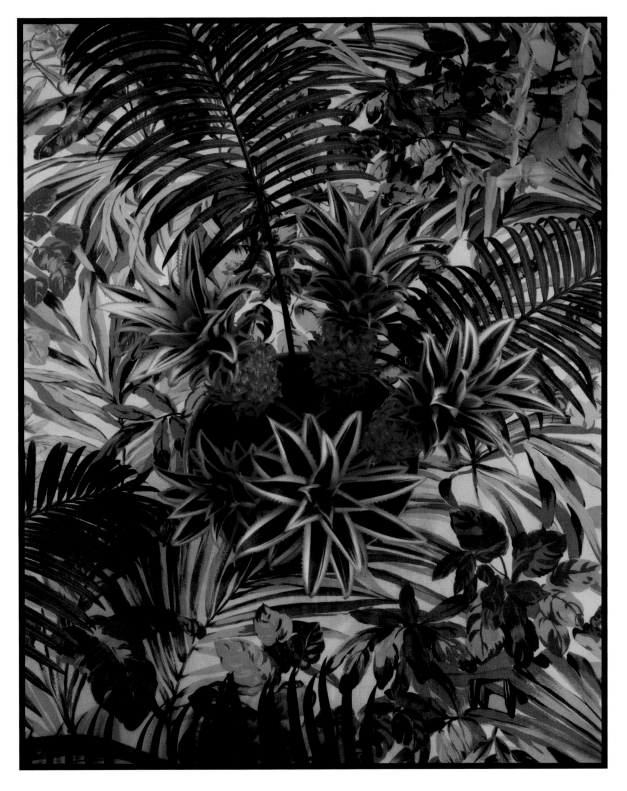

Plate 29

Ornamental Pineapples, Mill Valley, California, 1985

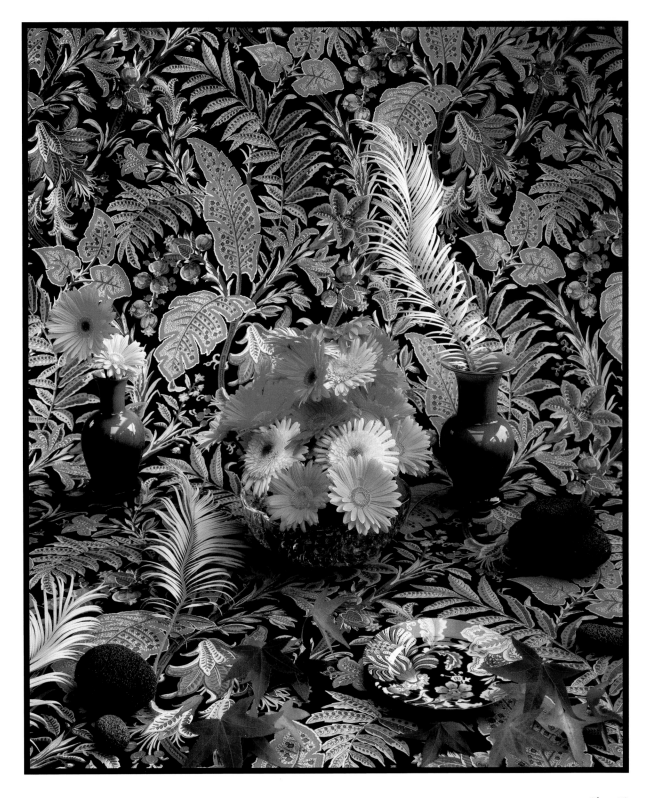

Gerbera Blossoms, Mill Valley, California, 1985

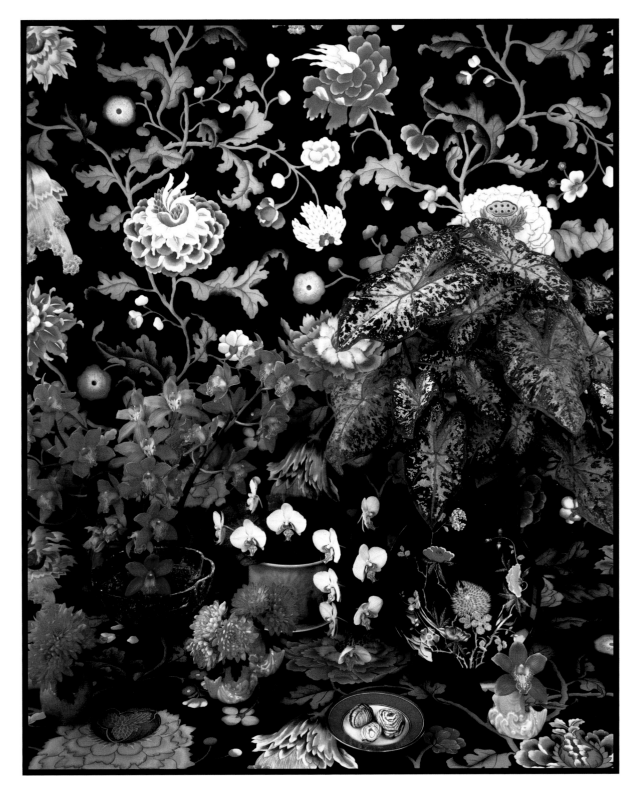

Orchids and Caladiums, Mill Valley, California, 1984

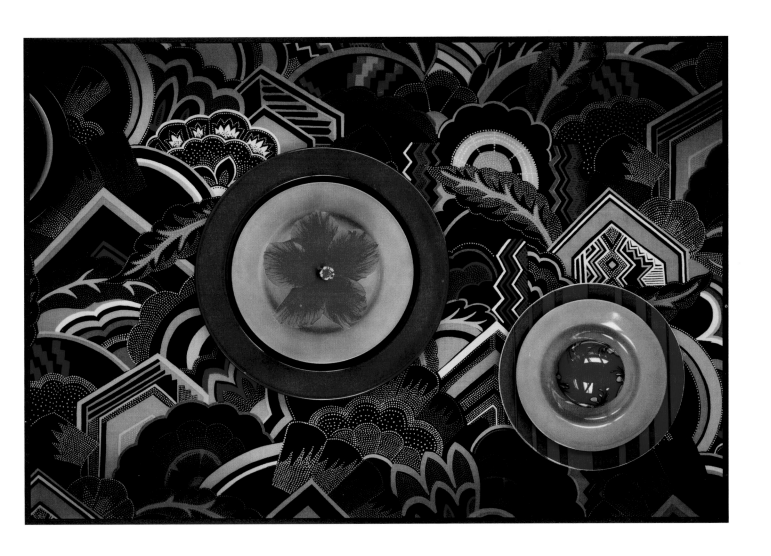

Plate 32

Hibiscus Blossom, Mill Valley, California, 1985

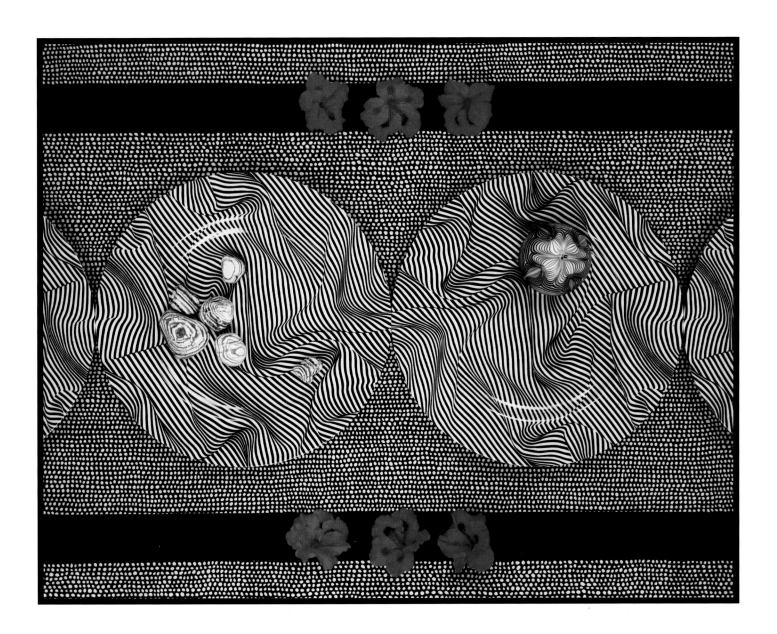

Plate 33

Pelargonium Blossoms, Mill Valley, California, 1985